VISION OF THE SERMON

THE STORY BEHIND THE PAINTING

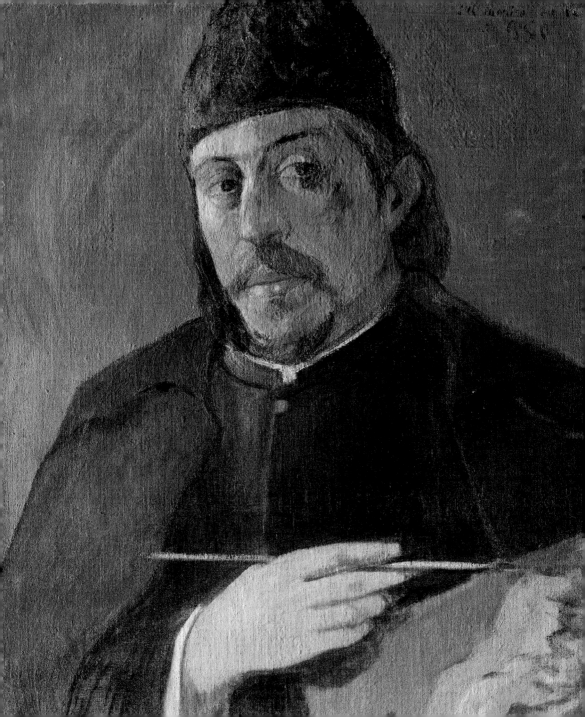

Belinda Thomson

VISION OF THE SERMON

The Story Behind the Painting

National Galleries of Scotland

2005

VISION OF THE SERMON

JACOB WRESTLING WITH THE ANGEL

You are right, my friend, I am a strong man who is able to bend fate to my desires; I can assure you that to do what I have done in the last five years has been quite a tour de force. I'm not talking about my struggle as a painter; yet that counts enough, – but about the struggle for life, with never a stroke of luck in my favour! ... I'll let you into a bit of my secret ... Instead of wasting my strength over work and worries that belong to the next day I put all my strength into the day itself. Like the wrestler who doesn't move his body until the moment he starts fighting.

LETTER FROM GAUGUIN TO DANIEL DE MONFREID, 11 MARCH 1892

When the painter Paul Gauguin (1848–1903) wrote these words from Tahiti, where he had been living for less than a year, to a faithful friend in Paris, the five years he surveyed must indeed have seemed momentous years of 'struggle'. Just prior to his dramatic flight from Europe to the South Seas, Gauguin had been living and working in Brittany. Earlier, he had worked for a time on the Caribbean island of Martinique [1], an experience which revived his childhood memories of the tropical heat and colour of Peru. In between times he had worked in Paris and spent a tempestuous two months in southern France, sharing the studio of Vincent van Gogh in

1 | Paul Gauguin, *Martinique Landscape*, 1887
National Gallery of Scotland, Edinburgh

Arles. All these upheavals had been motivated by the aim of enlarging the horizons of his art. In the five years from 1887 and 1892, Gauguin's painting style had indeed radically altered. He had also achieved a degree of fame as a group of younger artists looked to him as their leader, a number of critics had begun to defend him, and several collectors bought his work. Now, in Tahiti, he was fulfilling a long-held ambition to paint in tropical surroundings, in a climate suited to his savage 'Inca' temperament. Gauguin loved to nurture the myth of his exotic ancestry based on the fact that part of his family lived in Peru where he had spent his infancy. But to get to this enviable position Gauguin had made huge personal sacrifices.

Born in 1848, Gauguin had not started his career as a painter. He had been a merchant seaman for several years and then spent several more making money on the Paris Stock Exchange. When he married, in 1873, if his wife, Mette, was aware of his artistic interests she certainly did not expect him to give up his job a decade later to become a full-time painter. In 1885, frustrated in his attempts to make a serious career of painting, he had left his Danish wife to bring up their five children alone; an absentee father as far as their emotional needs were concerned, Gauguin now made only paltry contributions to their financial needs, picture sales being irregular and uncertain. It took Mette Gauguin a long time to reconcile herself to the change, particularly as Gauguin pursued his calling in an ever more single-minded way. After 1903 however, when Gauguin's posthumous fame started to spread throughout the world, she was prepared to admit that perhaps his belief in his talent had been justified and she did her best to promote his reputation.

Looking back in this Darwinian way on his 'struggle for life', Gauguin doubtless recalled the difficulties of keeping afloat financially, and the lack of recognition. He had given up the comforts of bourgeois life for a restless

and risky hand-to-mouth existence, begging his passage on steamers, and living on credit in country inns. For Gauguin was not content to be a moderately successful painter. He wanted to make a profound and radical mark. This involved going outside his comfort zone, setting himself new challenges both in terms of what and how he painted. He had even been prepared to forfeit his reputation as a decent human being, fighting his corner

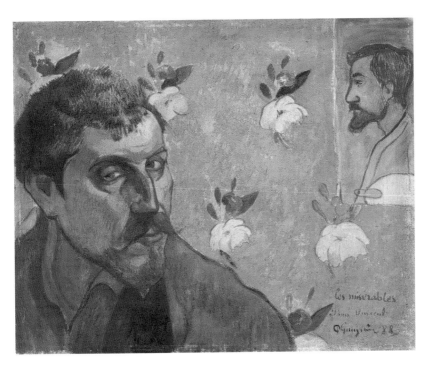

2 | Paul Gauguin, *Self-portrait: Les Misérables*, 1888

Van Gogh Museum, Amsterdam (Vincent van Gogh Foundation)

ferociously when the moment seemed right, trampling on friends' and comrades' feelings in order to further his career.

Although he was combative by nature, when Gauguin spoke of struggle and compared himself to a wrestler in his letter to De Monfreid, one suspects he did not draw the analogy at random. For the painting which had most effectively altered his recent fortunes – *Vision of the Sermon: Jacob Wrestling with the Angel* [17 and details] – was itself inspired by wrestling. Painted in 1888 in Brittany, it was the first painting in which Gauguin convincingly demonstrated his mature style, the distinctive style for which he would henceforth be known. It consisted of simplified, clearly-defined drawing to establish solid shapes and bold, non-naturalistic colours. Furthermore, his chosen subject for the composition demonstrated a new determination to paint not just what one can see, but what can be imagined. For some years Gauguin had been cultivating the simplified, naive and 'primitive', qualities he valued above all others in people and art. His aspirations came together in this arresting composition with its stark confrontation of pious simple-minded women in prayer and a famous biblical wrestling bout imagined by them in response to a sermon. To make clear that this was not a slice of ordinary life but a mystical vision, Gauguin reduced the scale of his wrestlers and placed them, like cut-out images from a story book or a stained glass window, onto a background of brilliant vermilion red. He had produced a painting unlike anything that had been done before.

3 | Detail from *Vision of the Sermon*, 1888
National Gallery of Scotland, Edinburgh

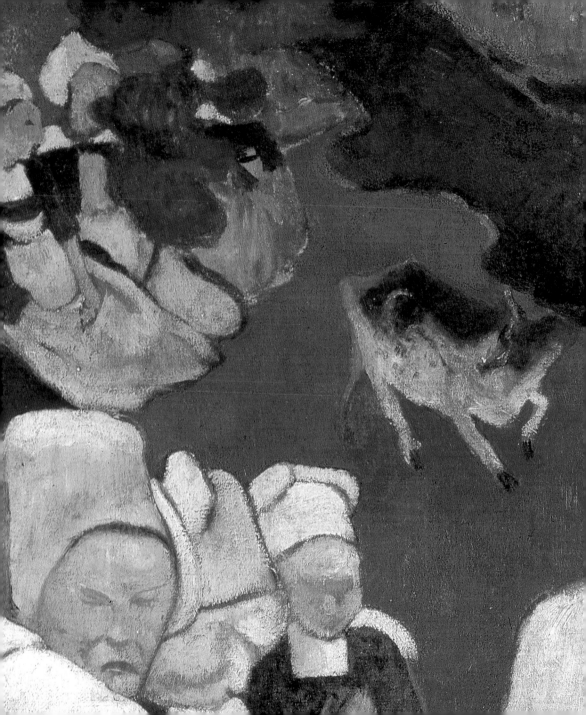

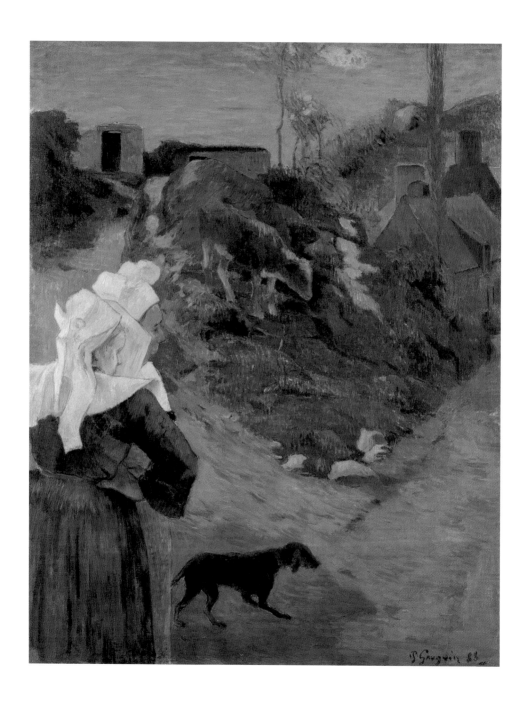

Like many rebellious artists, the first challenge Gauguin's radical painting made was to his immediate predecessors, which in his case meant the Impressionists. Gauguin had been invited to join the Impressionist group in 1879, five years after it had first formed; it helped that he was then a patron as well as an aspiring painter. Indeed, before launching himself as a full-time artist, Gauguin dabbled on the art market, buying and selling works by the Impressionists whom he greatly admired. Studying his own collection carefully was one of the ways he had taught himself to draw and paint, although he also had some help from Camille Pissarro, the oldest member of the Impressionist group. The two were very close in the early 1880s. Under Pissarro's tutelage, working directly from the motif, Gauguin tackled typical Impressionist subjects – portraits, still lifes, and above all, landscapes. Like Pissarro he painted some subtle transcriptions of nature's effects, using bright hues and broken touches of paint. When he exhibited with the Impressionists in the early 1880s, a number of critics commented on his over-dependence upon his master. Several dismissals of this kind hardened Gauguin's determination to go his own way, to shake off the imprint of Pissarro. Yet his *Landscape from Brittany with Breton Women* [4], painted in early 1888, the same year as *Vision of the Sermon*, is still reminiscent of Pissarro, who was renowned for painting unremarkable corners of nature animated by working peasant figures, rendered in a dense weave of close-toned brushstrokes.

The influence of other artists is evident in Gauguin's early work, for

4 | Paul Gauguin, *Landscape from Brittany with Breton Women*, 1888
Ny Carlsberg Glyptotek, Copenhagen

instance Paul Cézanne, the Provençal painter, a number of whose canvases Gauguin bought cheap at a time when they were spurned by the critics and public. Cézanne did nothing to encourage Gauguin's curiosity about his methods. Yet Cézanne's regularised directional brushstroke and high-key Mediterranean colours lie behind Gauguin's *Martinique Landscape* [1]. But where Cézanne sought to define volumes in nature, Gauguin's effects are more patterned and tapestry-like. A third important mentor was Edgar Degas [5], master of the modern figure and known especially for his ballet subjects. Gauguin's pastel and charcoal drawing, *Breton Girl* [6], with its informal pose from behind and its use of powerful hatching to give volume and texture to the model's costume, owes much to Degas's characteristic drawing style. It functioned in the same way too in that it served Gauguin

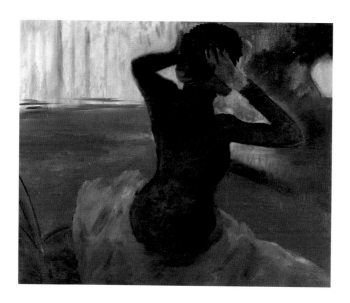

5 | Edgar Degas,
*Woman Adjusting
her Hat*, 1884
Private Collection

6 | Paul Gauguin,
Breton Girl, 1886
Glasgow Museums:
The Burrell Collection

7 | Paul Gauguin,
*Vase Decorated with
Breton Scenes*, 1886–7
Musées Royaux d'Art et
d'Histoire, Brussels

as the basis for several different works: not only did the pose reappear in an important figure composition painted that same year and a colour zincograph printed three years later, but it cropped up in the decoration of a ceramic vase. This *Vase Decorated with Breton Scenes* [7], one of several ceramics Gauguin made in 1886–7, ornamented with simple scored outlines and flatly applied colours, anticipates by almost two years the stylistic simplifications of *Vision of the Sermon*. Gauguin's 'synthetic' practice – that is, drawing individual figures and then assembling, simplifying, cropping and rearranging them into new compositions – was learned from Degas. Although their relations blew hot and cold, Degas was a vital source of encouragement for Gauguin and occasionally, at crucial junctures, paid him the ultimate compliment of buying his work.

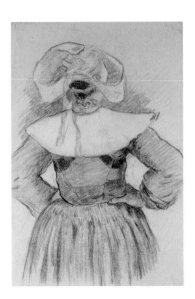

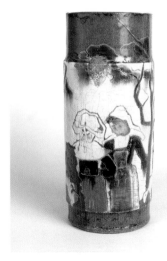

In early 1888 Gauguin made his second visit to Brittany, to the village of Pont-Aven. His first, in 1886, had been relatively short, but he had acclimatised himself to the potential of this picturesque site, making plenty of drawings and sketches of local figures and painting a few landscapes in an impressionist manner. Two years later, thanks in part to his Martinique experience, he was clearer about what aspects of Brittany he wished to capture in his art. 'I love Brittany' he told an artist friend: 'I find in it the savage and the primitive. When my clogs ring out on this granite ground I hear the dull, matt and powerful tone I am trying to find in painting.'

Arriving early in the year, he wanted to experience Brittany for himself for a few months, without the distraction of other artists. It was not the Impressionists or their followers that Gauguin encountered in Pont-Aven – on the contrary whilst there he could bask in the reflected glory of his membership of this 'intransigent' Paris movement. But the village had become a thriving, international artists' colony, and it was frequented in summer by artists from America and northern Europe. The art they produced was conventional enough, that is, mostly a form of naturalism, painted in a low-key palette with a near photographic attention to detail. It was the manner currently most in favour at the Salon. The Salon, France's official exhibition-cum-art fair held every spring in Paris, was an institution which Gauguin, like most of his fellow Impressionists, had come to regard with contempt. Confronting all these would-be Salon artists in Pont-Aven he loved nothing better, of an evening, than to taunt them with his own subversive, anti-naturalist theories. One of his favourite aphorisms in the summer of 1888 was: 'Art is an abstraction; extract it from nature while dreaming in front of it and pay more attention to the act of creation than to

the result.' When the inns filled up in the summer, Gauguin gathered quite a coterie of willing listeners. But being able to impress with acerbic words was one thing; he needed to prove his points in practice.

In all likelihood this hostile environment sparked Gauguin to challenge the conservatives on their own ground. It was a perception held widely at the time that Brittany was a region distinct from, and possibly superior to,

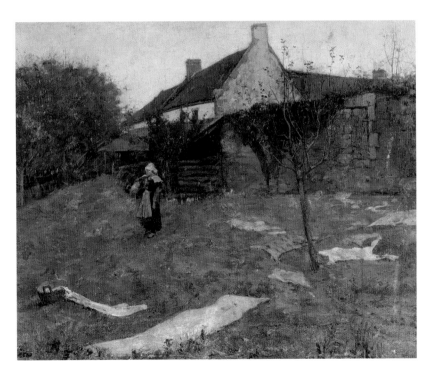

8 | Archibald Standish Hartrick, *Back of Gauguin's Studio, Pont-Aven*, 1886
Courtauld Institute of Art Gallery, London

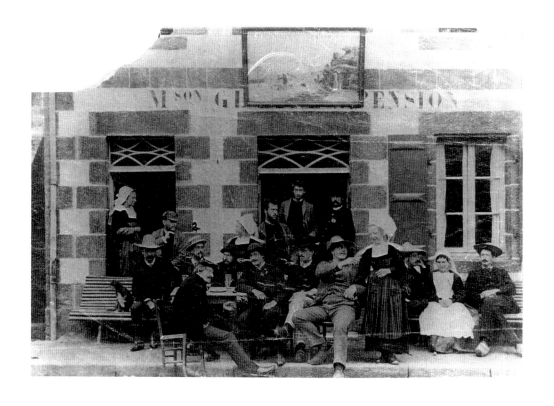

9 | Ferdinand du Puigaudeau, *Photograph of Artists Seated
Outside the Pension Gloanec*, 1886
Musée de Pont-Aven

10 | Paul Gauguin, *Landscape from Pont-Aven*, *Brittany*, 1888
Ny Carlsberg Glyptotek, Copenhagen

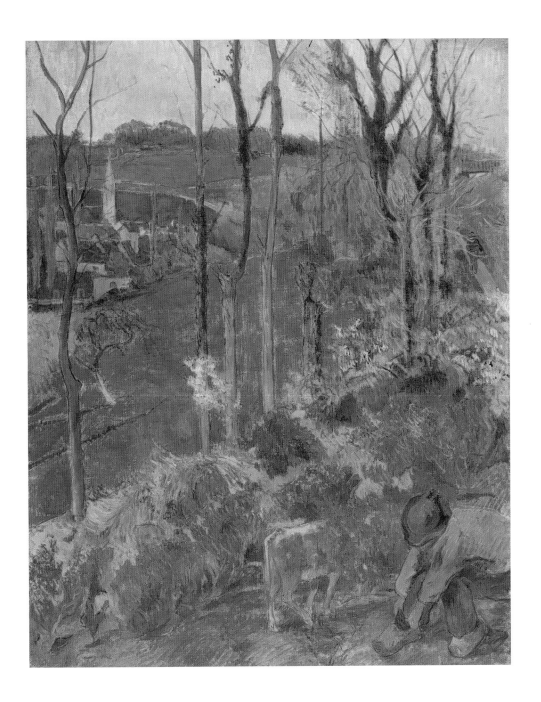

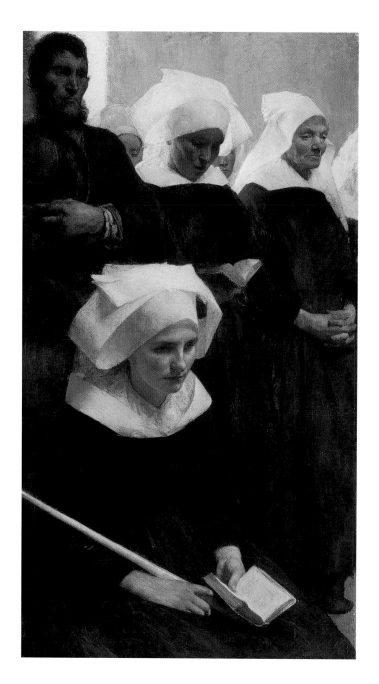

11 | Pascal Dagnan-Bouveret, *Bretons Praying*, 1888

The Montreal Museum of Fine Arts, William F. Angus Bequest

12 | Eugène Boudin, *The Pardon of Sainte-Anne-La Palud*, 1858

Musée Malraux, Le Havre

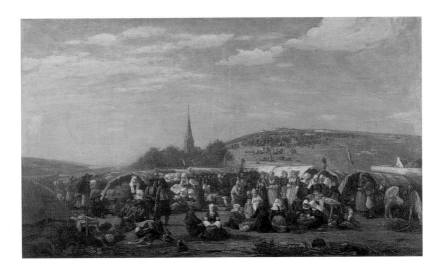

the rest of France by virtue of its long tradition of piety. A number of the painters working alongside Gauguin in Brittany were trying to capture on canvas the spectacle of Breton piety, particularly the picturesque and archaic religious festivals known as Pardons. Eugène Boudin had painted the *Pardon of Sainte-Anne La Palud* [12] for the Salon back in 1858. Pascal Dagnan-Bouveret, one of the most successful Salon painters of the 1880s, had revived the theme in an immensely successful series of legible, involving paintings [11]. Religious themes had been so far untried by the Impressionists, indeed, ran counter to their mainly progressive, secular views. Pissarro never showed his peasants in church or in prayer. But Gauguin was not a typical Impressionist. He decided to undertake his own religious painting, but instead of the prosaic and earthbound images of women in prayer he saw being attempted around him, he decided to tackle something more ambitious and difficult: a spiritual vision.

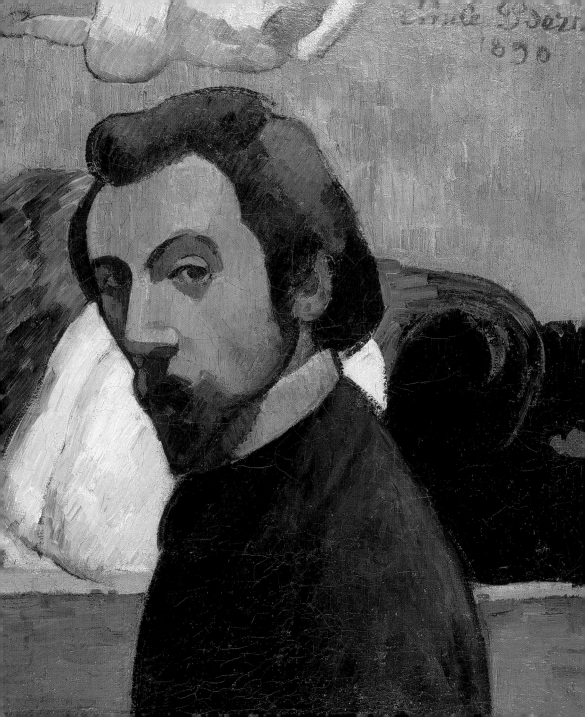

GAUGUIN AND BERNARD, SUMMER 1888

In *Vision of the Sermon* Gauguin had the courage to reject what he knew and, instead, set out to suggest a spiritual world of dream. Stylistically, in its bold and smooth planes of non-naturalistic colour the painting challenged the accuracy of the Salon painters. But with its pondered calculation of effects it also rejected Impressionism, an art developed to translate the immediacy of the artist's direct response to the seen world. More specifically it veered off in a new direction from the most up-to-the-minute variant of Impressionism invented two years earlier by Georges Seurat. Neo-Impressionism, as it was dubbed, was the avant-garde style currently dominating the exhibitions of Paris and Brussels. Gauguin had no time for such a fiddly technique or for its would-be scientific objective. For Neo-Impressionism involved the steady application of controlled dots of paint of contrasting hue across the canvas surface to convey the seamless vibrations of light in nature. Gauguin's new way of painting, involving firm outlines and areas of relatively unmodulated colour, was intended to convey emotions and ideas more directly. *Vision of the Sermon* was crudely realised, as Gauguin admitted to Vincent van Gogh, but he was satisfied with it.

What seems to have galvanised Gauguin at this precise juncture was his fruitful encounter and exchange of ideas with Emile Bernard [13]. Bernard was an exceptionally talented young artist who shared Gauguin's admiration for Cézanne and taste for caricature-like simplicity. The artists had already met on at least two occasions, first in 1886 in Pont-Aven when,

13 | Emile Bernard, *Self-portrait*, 1890
Musée des Beaux-Arts, Brest

according to Bernard, Gauguin had treated him dismissively. But at the time Bernard was only eighteen, and had been experimenting with the Neo-Impressionist manner Gauguin so disliked. According to Vincent van Gogh, a mutual friend and interested observer of their relationship, on their subsequent meetings in Paris Bernard had repeatedly picked quarrels with Gauguin. But at their decisive meeting in 1888, which had been engineered by Van Gogh, Bernard was quickly overawed by Gauguin's 'immense talent'; Gauguin, for his part, spoke well of Bernard, astonished by his uninhibited youthful daring.

So what had changed Gauguin's and Bernard's attitudes to enable them to respond so positively to each others' ideas in the summer of 1888? Was it the predominantly conservative surroundings that gave them a sense of comradeship as fellow innovators? Perhaps it was simply that their encounter happened at the right moment. The artists were at very different points on their career trajectories, Bernard just starting out, Gauguin, aged forty, at a now-or-never stage, aware that he needed to capture the public's attention with a striking and succinct statement in paint. He had been speaking of finding a way of getting beyond Degas's influence and experimenting with ways of expressing his ideas through simple, childlike, Japanese-inspired forms. *Vision of the Sermon* was not the only work he produced in this mood of combative opposition; there were other radical compositions such as *Still Life, Fête Gloanec* [14] and *Still Life with Three Puppies*, both painted on wood and perhaps conceived with a decorative end in mind. The impressionable Bernard, veering between extreme confidence and self-doubt, may have been flattered by Gauguin's encouragement and emboldened to go that bit further than he had dared hitherto.

The two artists executed some remarkable works that summer, evidently egging each other on in their conscious pursuit of the caricatural,

childlike and simplified. When Bernard arrived in mid-August, one of the most recent paintings by Gauguin he would have seen was *Breton Girls Dancing, Pont-Aven* [15], which Gauguin was about to send to Paris. Almost immediately Bernard painted *Breton Women in the Meadow* [16]. Given its identical dimensions and similarity of colour scheme and motif, one could see Bernard's painting as a caricatural exaggeration of Gauguin's graceful dance subject. For his part Gauguin must have started work on *Vision of the Sermon* in late August or early September as it was complete,

14 | Paul Gauguin, *Still Life*, *Fête Gloanec*, 1888
Musée des Beaux-Arts, Orléans

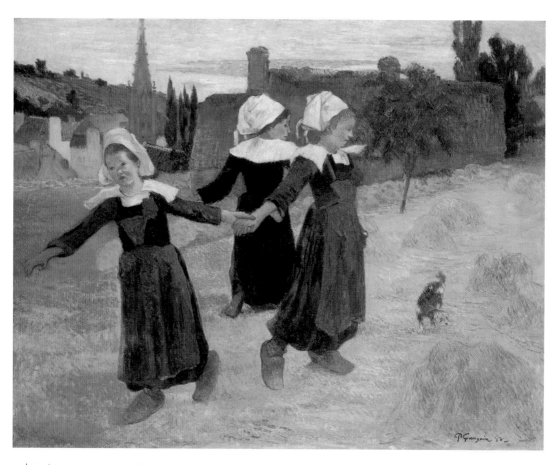

15 | Paul Gauguin, *Breton Girls Dancing, Pont-Aven*, 1888

National Gallery of Art, Washington, collection of Mr and Mrs Paul Mellon

16 | Emile Bernard, *Breton Women in the Meadow / Pardon at Pont-Aven*, 1888
Private Collection

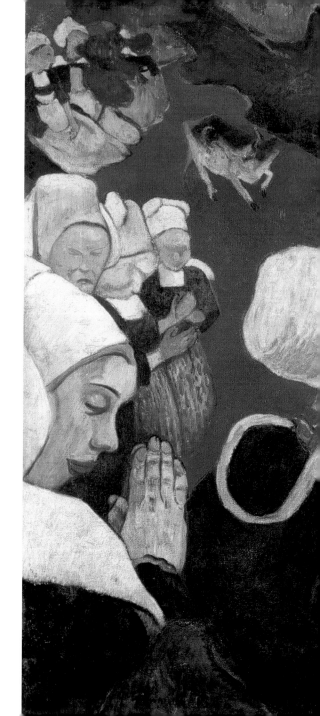

17 | Paul Gauguin, *Vision of the Sermon:*
Jacob Wrestling with the Angel, 1888
National Gallery of Scotland, Edinburgh

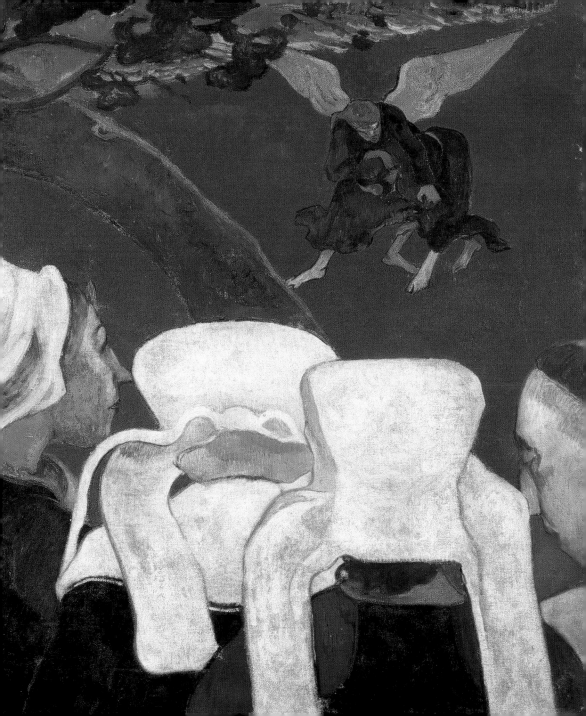

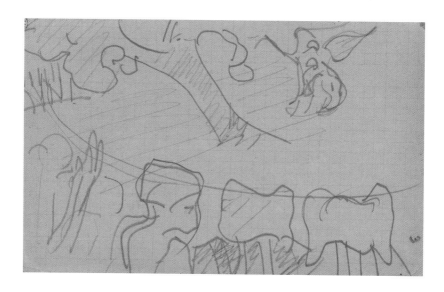

18 | Paul Gauguin,
preliminary sketch for
Vision of the Sermon,
1888, from Walter
Sketchbook

Département des Arts
Décoratifs, Musée du
Louvre, Paris

19 | Emile Bernard,
Buckwheat Harvest, 1888
Private Collection

or almost complete, by around 26 September, when he wrote to inform Vincent that he had just painted 'a religious picture, very clumsily done but it interested me and I like it'. Bernard and Gauguin's paintings have certain striking similarities – both have schematic, half-length representations of Breton women in the foreground, bold planes of colour and emphatic outlines whose effect tends to flatten perspective. Bernard's figures are clumsier and his contours heavier; they lie close to the surface like the metal divisions in a stained-glass window. In *Vision of the Sermon*, Gauguin's figures are carefully established, and his contours more integral to the composition, built up from a confident underdrawing which was itself based on a rapid drawing of the whole arrangement jotted on a sketchbook page [18]. This, puzzlingly, is the only surviving preparatory drawing for the painting. Bernard's Breton women, men and children are seen in random clusters, as though assembled from separate sketches. A plausible explanation for this is that they have gathered for a Pardon, much as in Boudin's earlier painting, and are idling and chatting while waiting for the main religious ceremony to begin. This was the reading insisted upon by Bernard himself when he exhibited the painting as *Pardon at Pont-Aven* in 1892 together with a similarly simplified, but more harmonious composition, *Buckwheat Harvest* [19], painted in that same summer of 1888. In this latter composition Bernard used a modulated red background, somewhat like Gauguin's, but with a clear source in nature, for buckwheat does indeed turn a bold red shortly before it is harvested.

The religious dimension is immediately apparent in Gauguin's composition which, as one might expect, is more complex and sophisticated than either of the works by Bernard. His Breton women are united in prayer. Positioned towards the edges of the canvas they kneel to form a circle around the wrestlers, from whose action they are separated dramatically by

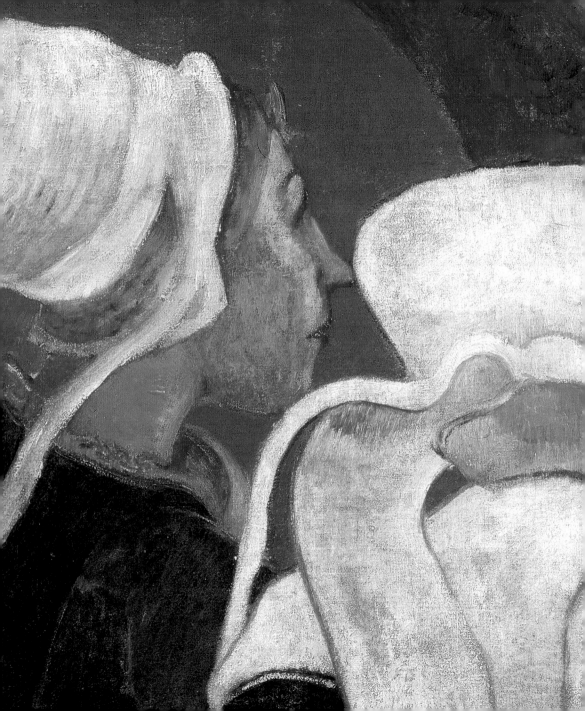

the diagonal trunk of an apple tree. While most of the women have their eyes shut, the viewer is encouraged to follow the upturned gaze of the woman in profile who focuses on the two wrestling figures, the angel, with gold wings outstretched, and the bearded Jacob.

The women's exaggerated white coiffes immediately denoted, in a highly decorative way, their Breton origins and thus their stark difference

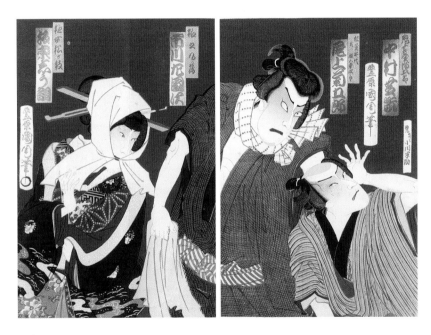

20 | Detail of *coiffes* from *Vision of the Sermon*, 1888
National Gallery of Scotland, Edinburgh

21 | Toyoharu Kunichika, *Two Sections of a Theatrical Triptych*, c.1870–80
National Museums of Scotland, Edinburgh

from the women of modern Paris. The deliberate primitivism of Gauguin's style further removed them from the everyday, just as their susceptibility to spiritual experience lay outside the rational norms of a modern, aggressively secularised society. Gauguin cleverly conceptualised his vision, making reference both to Japanese art, then all the rage among avant-garde French artists, and to the simple clearcut style and intense colour of the popular religious prints with which Bretons adorned and protected their homes. Then again his central theme, wrestling, was a traditional sport in Brittany, somewhat frowned on by the nineteenth-century Catholic Church but closely associated with the Pardon. Gauguin had first explored this theme in *Breton Boys Wrestling* [25], one of his first deliberate 'abstractions' from nature. It is likely that Gauguin, feeling embattled against the art world and bourgeois society, identified with this biblical theme of struggle and transformation – for after his night-long spiritual combat with the angel, Jacob is sent on his way with God's blessing and the new name of Israel. As an afterthought perhaps, in his desire to invest his religious painting with his own personality, Gauguin introduced his own unusual features into the figure on the lower right. This face, a late addition to the composition, is often read as a priest, presumably the priest whose stirring sermon has provoked the vision.

22 & 23 | Details of priest's face and wrestlers from *Vision of the Sermon*, 1888
National Gallery of Scotland, Edinburgh

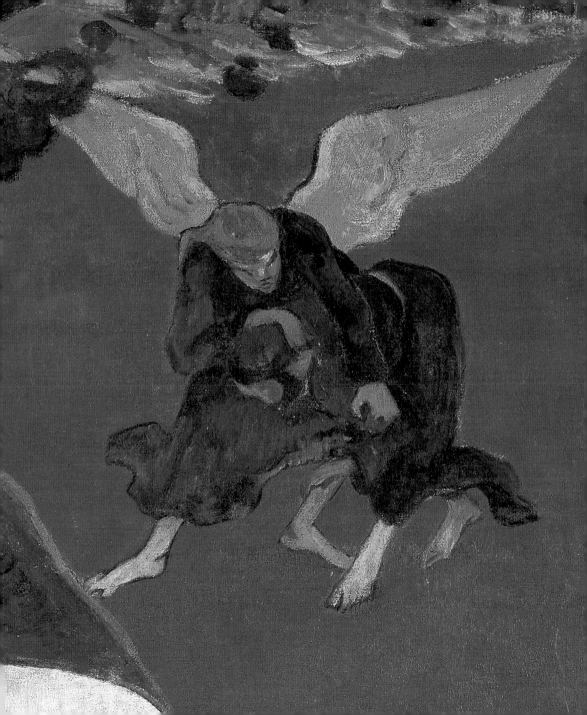

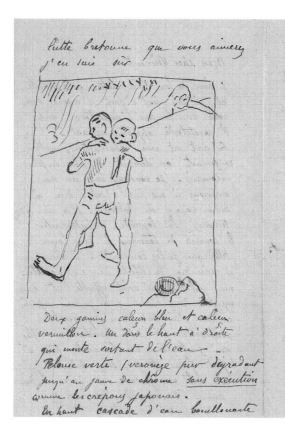

24 | Page of a letter from Paul Gauguin to Vincent van Gogh
with sketch of *Breton Boys Wrestling*, 24–5 July 1888

Van Gogh Museum, Amsterdam (Vincent van Gogh Foundation)

25 | Paul Gauguin, *Breton Boys Wrestling*, 1888
Private Collection

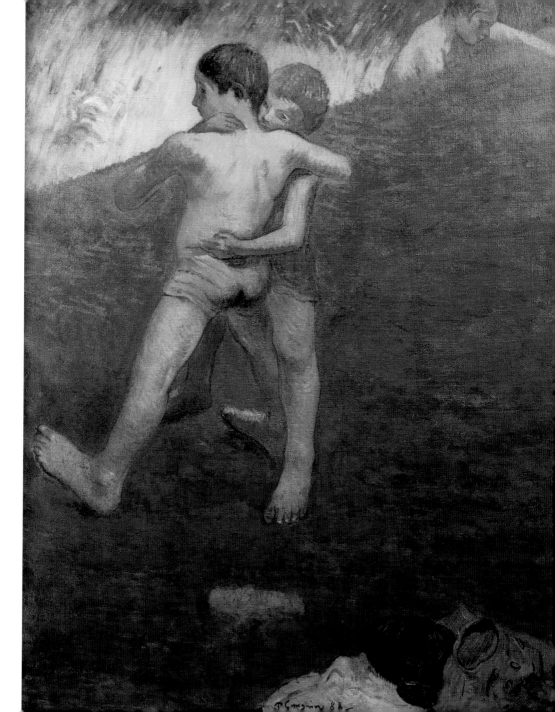

When it was completed Gauguin offered *Vision of the Sermon* to the church in Pont-Aven. The priest rejected it. Undaunted he tried again, this time taking it to the old church of Nizon, a nearby village [26]. Once again his offer was turned down. He was not surprised. Of course, seen with the eyes of his contemporaries, particularly curés who were unfamiliar with contemporary art, Gauguin's image was highly unorthodox. Compared with his notable artistic precedents, Eugène Delacroix and Gustave Moreau [27], Gauguin stylised the famous biblical wrestling bout beyond recognition, and relegated it to a corner of his canvas. Surely he could not expect to be taken seriously? In the event, happily for the spread of Gauguin's reputation, the picture was instead entrusted to Bernard who took it to Paris. Gauguin meanwhile went to join Vincent van Gogh in Arles.

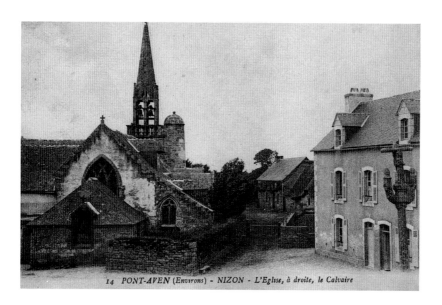

14 *PONT-AVEN (Environs) - NIZON - L'Eglise, à droite, le Calvaire*

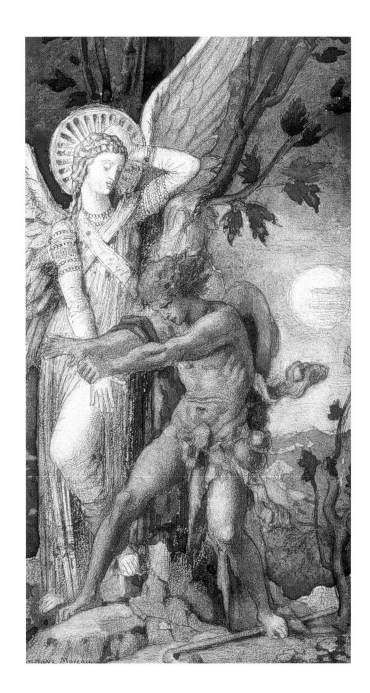

26 | Photograph of Nizon
church, *c.*1890
Courtesy Alain Le Cloarec

27 | Gustave Moreau,
Study for *Jacob Wrestling with
the Angel*, *c.*1878
Musée Gustave-Moreau, Paris

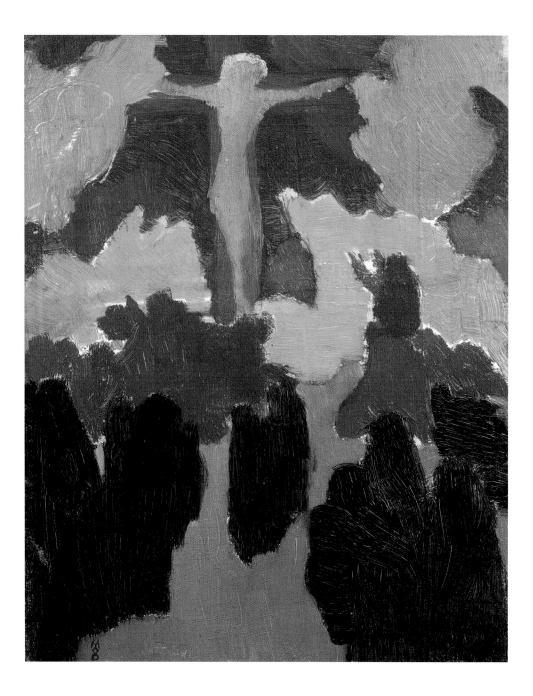

Gauguin first put *Vision of the Sermon* into the public domain by exhibiting it in Brussels in February 1889. Invited to take part in the annual show of *Les Vingt*, an advanced exhibiting group based in Belgium, he calculated on causing a stir with this and his other recent paintings. And seen against the luminous canvases of the Neo-Impressionists which dominated the exhibition, with their predominant harmonies of blue and green, *Vision of the Sermon*'s solid blocks of red struck a discordant note, and must indeed have seemed an act of defiance. The Belgian audience was baffled and hostile. Some detected a certain Japanese character to Gauguin's pictorial effects but could not understand the reason for it. One or two of the more sophisticated critics acknowledged his paintings to be indicative of a new emphasis in art on intellectual ideas. But incomprehension was widespread.

It took another couple of years before a groundswell of opinion in France began to reverse this negative verdict, and to hail Gauguin as an innovator, an artist who had opened up vital new directions for the art of the future. Gauguin's ideas had reached a number of discontented students who despaired of the mundane, materialistic values they saw in the art of the day. Paul Sérusier, Maurice Denis [28] and their friends at the Académie Julian rallied around Gauguin, following his example and developing his words into an eloquent radical credo. They formed the Nabis group, a Semitic word meaning prophets. Three key paintings by Gauguin which epitomised for them his importance and answered their

28 | Maurice Denis, *Orange Christ*, c.1890
Courtesy of Galerie Hopkins-Custot, Paris

hunger for an art of spiritual values were *Vision of the Sermon*, *Yellow Christ*, and *Breton Calvary* [29]. In March 1891 Gabriel-Albert Aurier, an ambitious young critic, praised *Vision of the Sermon* to the skies, describing its creator as a genius, a visionary, the first exponent in painting of what was an important new movement in literature, Symbolism. Where the majority of viewers saw in *Vision of the Sermon* nothing but a distortion of natural appearances, exaggerated, absurd colours, and an offensively crude and cruel depiction of simple Breton folk, Aurier saw the expression of the essential mystery of religious belief. Once it was understood as a symbolic representation of an idea, Gauguin's exaggerations were justified, indeed were the necessary vehicles for his composition to achieve its deeper meaning.

But not all saw him in this light. The painting's success aroused anger and jealousy in other quarters. His former mentor and friend, Camille Pissarro, could not stomach Gauguin's move away from the essentially democratic principles of Impressionism towards the mysterious, the Catholic and the spiritual. Whilst he was prepared to grant that Gauguin had considerable talent, he detected hypocrisy beneath his elevated new status: 'Gauguin's no visionary, he's a schemer who has sensed a reaction on the part of the bourgeoisie, in response to the great ideas of solidarity that are burgeoning among the people … !' But the person most upset by Gauguin's critical success was Emile Bernard. He felt cheated; what had been a combined effort was now being trumpeted as Gauguin's solitary achievement. He was particularly aggrieved that Aurier, whom he had introduced to Gauguin, should have failed to even mention his name. He blamed

29 | Paul Gauguin, *Breton Calvary / Green Christ*, 1889
Musées Royaux des Beaux-Arts de Belgique, Brussels

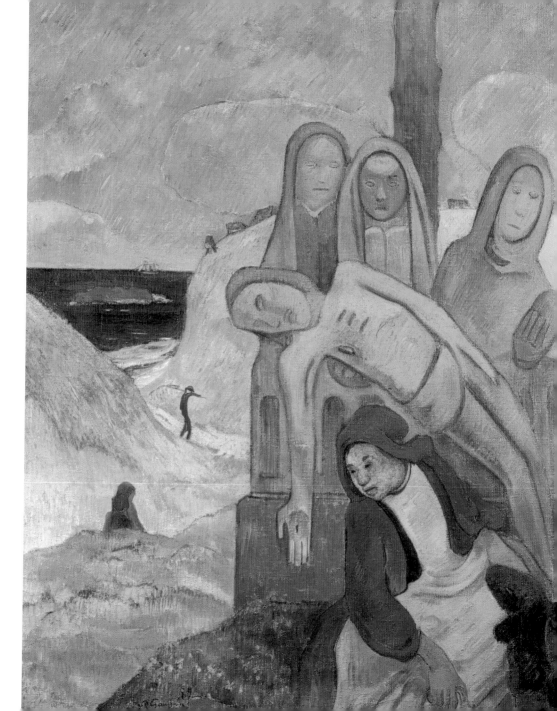

Gauguin too, for allowing this to happen, for the ruthless way in which he had promoted himself at the expense of his erstwhile comrades. Indeed, in a sense, through this effectively stage-managed publicity campaign, through this re-branding as a Symbolist with which he actively colluded, Gauguin had, in his own words, bent 'fate to his desires'.

Sadly Bernard's claim to be recognised as a crucial catalyst without whom Gauguin may never have painted his radical canvas became magnified from a grievance into a major lifelong campaign to rewrite the history of their relationship. Denied a place in the sun, Bernard resorted to intemperate denigration of the artist whose gifts had so overwhelmed him when they worked together. Much ink has been spilt in defending the cause of one or the other artist; but whatever the justice of the original claim, the historical fact remains that while as a critic Bernard made an important contribution to the appreciation of Cézanne, as a painter he had given of his best by 1890. After passing through a number of uncertain phases, he moved definitively away from the ideas he had shared with Gauguin and away from the modern, back to a re-evaluation of the old masters. Gauguin, on the other hand, was able to build upon the foundations he had laid in *Vision of the Sermon*. It was the first painting in which Gauguin combined a style which was self-consciously primitive with a religious subject, thereby tapping into a theme that proved fertile for his imagination for years to come.

Just prior to Gauguin's departure for Tahiti in April 1891, *Vision of the Sermon* sold at auction for 900 francs, a modest enough sum but greater than the prices fetched by his other works. Its sale was greeted by cheers from his supporters. They recognised the special qualities of this work and its importance to Gauguin's career. The painting remained in the collection of Meilheurat, its first owner, for some twenty years before returning to the

art market in 1911. Its second owner was Michael Sadler, an enterprising collector from Leeds. Significantly, Sadler also bought two other major Gauguin works, which continued this potent but ambiguous religious theme: *Christ in the Garden of Olives* in which Gauguin made so bold as to fully identify his own sufferings with those of Christ, and *Manao tupapau* or *Spirit of the Dead Watching*, painted in Tahiti [30]. Here, as in *Vision of the Sermon*, Gauguin the sceptical Frenchman explored an unfamiliar culture,

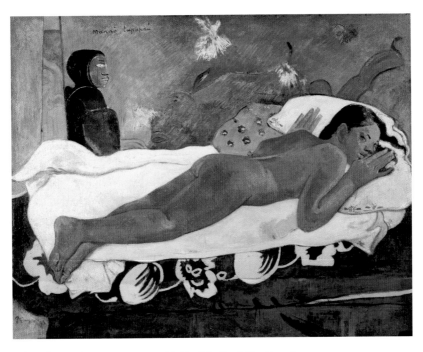

30 | Paul Gauguin, *Manao tupapau / Spirit of the Dead Watching*, 1892
Albright-Knox Art Gallery, Buffalo

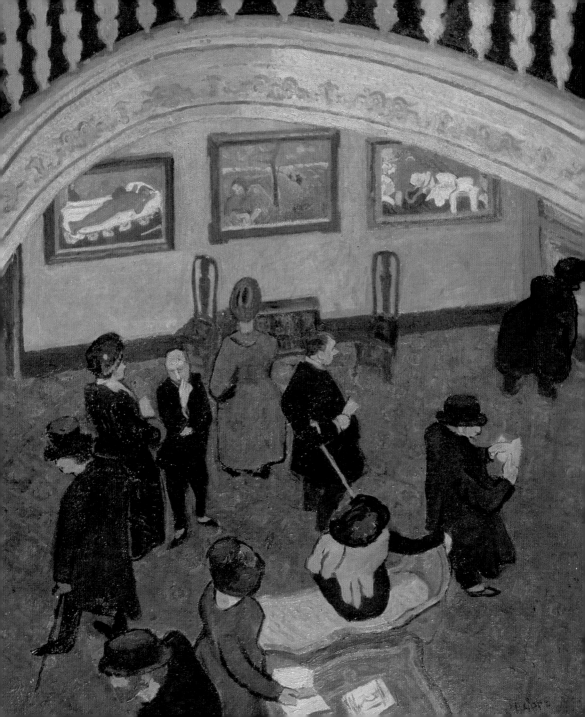

a susceptibility to religious belief that lay outside his own experience, in this instance staging on his canvas an encounter between a simple, unsophisticated and credulous Tahitian woman and a ghostly presence bearing intimations of the beyond.

Sadler's enthusiasm for Gauguin was part of the new and infectious vogue for advanced French painting among the cultural elite in England, who longed to distance themselves from the Victorian past and espouse an art of modern, spiritual purity. The vogue had been triggered in 1910 by a ground-breaking exhibition organised in London by Roger Fry [31]. The formal, expressive and painterly values of French art were newly defined by Fry as 'Post-Impressionist', a label which was to have considerable success in Britain and America. It relaunched Gauguin, Van Gogh and Cézanne, all of whom were now dead, as heroes for a new generation. And in Gauguin's case, his dramatic life, his flight from Europe in order to live 'as a savage', only enhanced his appeal for his twentieth-century admirers. In 1925, Sadler agreed to sell *Vision of the Sermon* to the National Gallery of Scotland in Edinburgh, where it has become and remains one of the Gallery's most popular and admired works. And rightly so, for *Vision of the Sermon* was the painting which first enabled Gauguin to go beyond the prosaic limitations of naturalism, to evoke the realm of imagination and dream, and ultimately to realise his dream to become the painter of the tropics. There is no question that this arresting and remarkable painting has made its mark on the course of Western art.

31 | Spencer Gore, *Gauguins and Connoisseurs at the Stafford Gallery*, 1912
Private Collection

1848
7 June, birth in Paris of Eugène-Henri-Paul Gauguin, second child of Clovis Gauguin (d.1849), republican journalist, and Aline-Marie Chazal (d.1867); grandson of radical feminist, Flora Tristan (1803–1844).

1849
Early years spent in Lima, Peru, home of Aline's great uncle, Don Pio de Moscoso. Gauguin later flaunts this exotic childhood and 'Inca' ancestry.

1854–65
Paul Gauguin attends schools in Orléans (Jesuit seminary) and Paris.

1865–71
Joins merchant marine and then navy. Voyages in Europe and South America.

1872–83
Works for various employers on Paris Stock Market.

1873
Marries Danish woman, Mette Sofie Gad, who bears him five children, the last born in 1883. Attends evening art classes.

1876
Landscape exhibited at Paris Salon.

1878
Receives informal tuition from Camille Pissarro. Collects Impressionist art thanks to period of successful speculation on Stock Exchange.

1879
Invited by Pissarro to take part in 4th Impressionist exhibition. Contributes to all subsequent Impressionist exhibitions, 1880, 1881, 1882, 1886.

1883
Resolves to concentrate full-time on painting.

1884
Moves with family to Rouen, then Copenhagen, in attempt to economise.

1885
Leaves family in Denmark and returns to Paris. Winter spent in dire poverty.

1886
First stay in Pont-Aven, Brittany. In Paris makes first ceramics.

1887

April to October, travels to Panama and Martinique with Charles Laval. In Paris meets Vincent van Gogh. Theo van Gogh becomes his dealer.

1888

February, returns to Pont-Aven. August, joined by young painter Emile Bernard. Intensive period of radical work. Paints *Vision of the Sermon*. October, joins Vincent van Gogh in Arles. December, Van Gogh's breakdown prompts return to Paris.

1889–90

Exhibits *Vision of the Sermon* in Brussels to mixed, mostly hostile, reviews. In Brittany, joined by new followers; divides time between Pont-Aven and Le Pouldu. Plans longer trip to tropics.

1891

Publicity campaign singles out *Vision of the Sermon* for praise and hails Gauguin as leader of 'Symbolism in Painting'. Rift with Bernard. Auctions work in Paris. Departs for Tahiti.

1893

Returns to France. Exhibits Tahitian work at Durand-Ruel gallery. Wife Mette breaks off relations.

1894

Spends spring and summer in Pont-Aven. Injures ankle in brawl.

1895

In poor health, returns to Tahiti.

1903

8 May dies on Hiva-Oa in the Marquesas Islands.

32 | Gauguin in 1891 wearing a Breton waistcoat

Published 2005 by the Trustees of the
National Galleries of Scotland, Edinburgh

ISBN 1 903278 69 4

Designed and typeset in Fournier by Dalrymple
Printed in Belgium by Die Keure

Cover: Paul Gauguin, *Vision of the Sermon:
Jacob Wrestling with the Angel*, 1888 (detail)
National Gallery of Scotland, Edinburgh

Frontispiece: Paul Gauguin, *Self-portrait with Palette*,
c.1894, Private Collection

This book was published at the time of the exhibition
Gauguin's Vision held at the Royal Scottish Academy
Building, Edinburgh, from 6 July to 2 October 2005.
The exhibition was sponsored by Baillie Gifford & Co,
investment managers.

If you have enjoyed this short book and would like
more information, the exhibition catalogue is available
from: NGS Publishing, Dean Gallery, Belford Road,
Edinburgh EH4 3DS

www.nationalgalleries.org